RECHELESSE PRATTICQUE

RECHELESSE PRATTICQUE

Karen Mac Cormack

chax 2018

Acknowledgements:

Some of these poems have appeared in *The Other Room*, *Yellow Edenwald Field*, and online. "Various Turns" manifested as DUSIE Tuesday Poem #49.

The poem "Words Pronounced Exactly Alike" first materialized as a collaborative bilingual English/Swedish broadside in 2014, Fredrik Averin being the translator, designer, and publisher of this silkscreened limited edition of 42 copies. My thanks to the editors and publishers.

The cover image is *Callicoon Center Car Show*, by Stephen Andrews. Watercolor pencil crayon on mylar. Used with the artist's permission.

Library of Congress Cataloging-in-Publication Data

Names: Mac Cormack, Karen, 1956- author.
Title: Rechelesse pratticque / Karen Mac Cormack.
Description: [Tucson, Arizona] : Chax Press, 2018.
Identifiers: LCCN 2018016923 | ISBN 9781946104137 (pbk.)
Classification: LCC PR9199.3.M2 A6 2018 | DDC 811/.54--dc23
LC record available at https://lccn.loc.gov/2018016923

Chax Press is supported in part by the School of Arts & Sciences at the University of Houston-Victoria. We are currently located in the UHV Center for the Arts in downtown Victoria, Texas. We acknowledge the support of graduate and undergraduate student interns and assistants who contribute to the books we publish. In Spring 2018 our Student Assistant is Jennifer Hernandez. Chax books are also supported by private donors. We are thankful to all of our contributors and members. In Summer 2015 Chax will move to Tucson, Arizona, but also maintain operations in Victoria, Texas.

Please see *https://chax.org/support/* for more information about contributing to Chax Press.

for my Cushla

CONTENTS

. . . and by the worke of my pen and inke, have dzinkhornifistibulated a fantastical Rapsody of dialogisme, . . .

— *The Parlement of Prattlers* (John Eliot, circa 1593)

words as we do not (yet) know them

in languages ever

since context is a texture

to adhere or tear

what isn't paper

still as ink

some time spun — is heaven to be horizontal?

severally singular: a comment in parts

Any each we roam what *is* improbable and a likely score's not out . . .

For example, in the sixties flies under crystal were popular; in the seventies earrings in the shape of hammers, tongs or ladders . . .; while demiparures of locomotives were worn in the eighties . . .

Each moment's senses do or don't align . . .

Two reasons can be suggested for this: first, the discovery of diamonds in South Africa in 1867 made these stones more plentiful and cheaper (*Aside*: cheaper for whom?); secondly, the growing use of electric light with its hard brilliance may have caused the elaborate jewels of many colours to look too garish.* . . .

How *would* 'canary yellow' translate into a language whose speakers have never seen such a bird? . . .

The people who destroy old watches to make this horrid use of the pierced cocks . . . were the same who a few years ago destroyed medieval books to torture the wrought clasps into the ugliest of belts . . .

N/vers or N/ever's negative always — iridescence a binary undone . . .

ver F. worm
vers F. verse

❧

1.

then before *when* the alphabet's

code intersects or faces grammar

temporal gravity for mission/misprision

accompliced anew scene

another chance

into any never

say never again

a way becomes motion's aweigh

successive percussive

sighing on

2.

then code temporal accompliced another into say a successive sighing

before intersects gravity anew chance any never way percussive on

when or for scene never again becomes

the faces mission motion's

alphabet's grammar /misprision aweigh

3.

when or for scene motion's

the faces mission/misprision motion's

alphabet's grammar aweigh

Film two nights are not two sisters

Really existing

to put into action

loveliness

setting fire to places

a reason offered; controversy

to increase

fruit-time

concurrence

the west sets

exact limitation

motive

a corrupt dialect

capable of admitting

to go beyond

more than enough

series

following in order

repetition; rehearsal

discourse addressed to the passions

decisive

inclination upwards

gardening

secret unknown

amusement, diversion

something growing out of another

hindrance

a combination of circumstances

to happen

accidental event

productive of effects

skilled in any art or science

excessive

to draw a conclusion

distrust

furniture attached to a house

representing something else

a bending; modulation of the voice

flowing into one another

plenty beyond necessity

having a tendency to fly from the centre

lustre

the act of melting

to intimate

a case denoting possession

elegant in manners

departure out of

custom

existing in

concurrence of circumstances

to glide away

declaration

the act of choosing

to abandon

talkativeness

an introduction

that has been washed down a river

authority

to be left

pressing necessity

proportionable to each other

changing of place

elevation

mixed of various kinds

coming by starts

at a distance

reciprocal

growing

exposed

a vocabulary

mode of utterance

sweet scent

eloquence

to recall

a painting

something to fill up

manifold

arrangement

easily carried

rumour

yielding to pressure

to cross out

credit, character

swift

ruling

breach

pleasing to taste

connected with science

contribution to any undertaking

writing on the outside

the point where lines cut each other

to set aside

succeeding part; event

a discourse

instrumentally useful

space between things

incapable of separation

watchful on every side

curved, winding

a restoring

to determine beforehand

that which compresses

information; command

nearness

outward show

holding fast

woven together

twists out of form

the region; a little book

equal in value bending

outward

a chance

cross-wise

shift

to confute

the sound of the mouth

a rolling about

to fall into new hands a

turn, a rotation acting

by choice

to dedicate

voice given

an instrument

to read

.

1025 again

name another city in the window

is distance to rebuke entering

and if not *now* an inclination

goes diagonal sleight of hand

a detail reminiscent to agreeable

rising temperature

falls the verb

ALFABET

as in bib as in this as
in pip as in thin as in gig as
in maim as in kick as in noon
as in did as in sing as in tat
as in lull as in vivid as in
roar as in fife as in you as in
vision as in way as in show
as in hay as in zigzag as in
judge as in church as in me
as in pity as in age as in beg
as in far as in at, air as in
do as in full as in no as in
cut as in fall as in on, or as
in ice as in oil as in dew as
in owl

the goddess of mischief provides dress-devoured garments a mat used civility the lower notes in music made to strike by women conquer one who denies a fellow French coin to crack the skin by cold goes under water burn wood to charcoal the rich man takes food free from dirtiness to complete more excellent rather a child's first book figure shape likely a long seat that can be probed quarter of a pint to place an opening on each side a game at cards painful disease thinness tastes a large black bird backward to peruse contrary meaning a town in Berkshire partaking of iron aforesaid petty work did say man's name a sort of net to conduct a river of France soft heavy metal to part intelligent skilful disjoined did drain plural of life deep miry place dwells a serpent's cast skin on animals' necks to stay departed spirits smeared with tar or regulate water from the eye temperate to rend remarkable in a direction careful bustling ready to do or learn reckoning a sluice more torpid use as clothes to fold to twist to braid in motion brighten twisted belonging to hurt the head a tax woollen yarn a parrot's name defeated

Various Turns

commonly

in place of

word for word

against

a comparison

to regular order

prescription

a detail with reasons

proportionate share

as far as

the plan of a forthcoming book

more

everywhere

state of equality

for all

a memorial

writ commanding

letter for letter

also; an article

extemporaneous composition

in the first place

let it be printed

in the same place

freely

a decree unpremeditated

departure

therefore

erase or expunge

mark used in interlineation

an additional premium

in English

elsewhere

;

intoo

u

w

o

p

d

s

e

i

d

d

i

e

s

d

p

o

u

w

into

u

p

s

i

d

e

d

o

w

in two

upsidedown

upside down

up sided own

into

intoo

in two

d own u in too

e p w

d i s o

i n i d

s t d e

p w e d

u o i

 d s

 o p

 w u

 into

upsided own in two

upside down into

upsidedown in too

post blast collection (two sets of variations)

what happens when the waiting weights no more?

anterior to movement such emphasis
not for a moment shadow-whisper
given volume to glister
entry as pre-position
low blur

optic
finesse

diverts the perpendicular
even to empty articles
accordingly or spacious
tenses reverberate a plane
hovering comes to mind

(for AB)

about	because	each
accordance	before	editor
advertisement	behind	enough

; in memory of the Ambassador; a professional revolutionary; potatoes, tomatoes, and other vegetables; extremely convenient apartment; includes almost everyone; miscellaneous furniture; agriculture for instance; several significant facts.

below	February	after
against	beside	figure
from	between	acknowledge

About two-thirds of; fifthly; south-southwest; northerly winds; westward movement; threefold increase; the twelfth century; the second Monday in March; on Fourth Avenue; equalled one thousand dollars; three Tuesdays.

acquaintance	beyond	grammar
ignore	chapter	area
attempt	company	known

I am myself; you are yourself; they are themselves; no one anywhere; everybody everywhere; every one of the boys; of no value whatever, whenever or wherever it happens; where everyone is equal to everyone else; please do something!

scientific	indeed	union
which	information	September
singular	inside	wrote

Hyperthyroidism; physical inactivity; an idiosyncrasy of his; as a prophylactic measure; famous as a lyric poet; the book *This Simian World*.

spelling	interest	except

examine	often	square
exquisite	opinion	experience

;some probability of reorganization; some revolutionary rhetoric, remember that old-fashioned restaurant; romantic atmosphere; in an imaginary language; obviously not his own automobile; ordinary vocabulary.

There is abundant evidence that there has been a trend towards shorter sentences since the seventeenth century. (Not(e)Script)

for WR

when in difference
as with affect
if if so
where *be* falling
similarity is such
me and or
too senses sure
episode since

an assistant to a general in the fashion seasonably polite literature a love-letter with good or ill will witticism high fashion from head to foot unconditional terms a master-piece sort of spiked fence as it should be permission to elect the finishing stroke bold stroke a glance of the eye breakfast with a last resource and my right double meaning between ourselves a fault; misconduct discharge of fire-arms disabled I know not what witticism play on words false modesty an assumed name flying report stratagem of war coolness, indifference private conversation the whole a face to face

the foregoing attempt

There are my images, I use them, not to answer but to hear.

— last line of the late John Riley's poem "With Heavy
 or Light Heart"

alienation of mind a place of trade

 the time between

an empty space

 good or bad token

 a many-footed animal

 the nightmare

 action of a play equality of weight

an ancient phrase the Aegean Sea

original art of building

relating to the stars calamity, misfortune

tossed from one to the other a question proposed

talking by the hand a manual

not giving colour to objects performed in equal times

precious stones the number ten

having filaments in many sets peculiar to a country

deviating from established opinion

a race-course the same if read backwards

to impel construction the science of magnitude

a comment of many languages well-delineated

the first draught of a picture writing by sound

emerging from, or falling into dissimilar

departure from original having the same proportions

folly a primary disease

selecting a preface

the derivation of words mode of speech

complicated construction an act of oblivion

unconnected effusion without a name

having the same meaning an accute accent

relating to remedies circumference

the nightingale an instrument to measure intensity of light

circumlocution having the power to give form

versed in affairs a citizen of the world

that multiplies sounds talkativeness

a description of rivers the first part of an ancient play

adoration of fire highly defined

people whose shadows turn all round aim, space, liberty

a turning from the main subject to another

act of joining the subject of an argument

to explode description of a place

the apparent path of the sun carved on it

pretence small island in a river to dissemble a number

fourscore mode of speech sort of door apart in music

manner of walking to take less an allurement bay trees

mixed colours frozen rain an exclamation period of time

intricate place three at cards uneasiness a road

to swim with sails price of passage a game cut thinly

allowance in weight increases to strike an almanac

part of a circle to push to sea distinct action

talons part of sentence opposite to the wind willingly

to encounter measure unmixed water from the eye

a discourse you and I seven days yielding climate

amber conducted space upwards yes to write a fluid

geometrical line a situation more precise to twist

duration alone not so to understand twice two

what anyone knows best in such a manner link

moisture to call aloud a colour performed

flow with a murmur brinks or edges belonging to us

part of the day

Out of Number

Part A

It's said that . . .

>People say that . . .

I've been told.

>That's to say . . .

It's hard to say.

>Say it!

Say it.

>Say it again.

Say it slowly.

>Don't say it.

Don't say that.

>Well, tell me.

Say . . .

Say, you're not serious, are you?

Tell me.

Say it to me. Tell me it.

Tell him.

Tell it to him.

Tell him to come.

Don't tell it to him.

Don't tell him anything.

Above all, don't tell it to anybody.

What did you say?

What do you mean?

("What do you want to say?")

He hasn't said anything.

Part B

Come with me.

I'm coming right away

That's to say . . .

It's hard to say.

I've just done it.

Tell me.

I'm doing it.

I don't do it.

How do you do that?

What have you been doing?

Don't do it!

Don't do it anymore.

It's done. It's over.

Two and two are four.

That hurts me.

I'm not doing anything.

That doesn't matter.

It doesn't matter at all.

It doesn't matter to me.

Do that.

Don't do it!

Do it again.

Do it once more.

Do it quickly!

Don't do anything.

Pay attention!

Mind what you're doing.

Pay close attention.

Don't mind that.

That mustn't be done.

I've just done it.

May I? Please do! Go ahead.

What's to be done?

What shall we do?

What can be done?

("What to do?")

How shall we do it?

Who did that?

I don't know what to do.

Do that!

Do it quickly.

What are you doing?

What have you done?

Don't do it.

It's done. It's over.

That makes a difference.

Never mind.

It doesn't matter at all.

"One more time."

I've just done it.

Who did that?

Say it in French.

18 April 2016

❦

whether falls on any side of language

a persuasion's nameable

decision disembarks full moon

nautical minus ink following

flows flaws eftsoons

sunset sink

from one vowel descending

meaning changed becomes

entwined with capitol

I's interest interstitial

BROCATELLE

My home

is no fixed point

but a refuge that wobbles. — Alda Merini

(Scene)

of course they are a group of rooms occupied as a unit recently mutual there-

their street purpose probable I contains 30 brief forms and derivatives *Is*

intuition a form of temporal synaesthesia or: a möbius strip, seam, or fold? requiring

careful handling or nor more store ignore floor (The above

sentence could be written as two.) annual schedule actual actually

annually perpetual to transcribe facts that cannot be denied classic

basic topic graphic traffic logic magic *In the decays of strange*

particles, strangeness is not the same on each side of the reaction. That doesn't seem

possible on the way to *understood.* Timely fit so minimum balance accommodates

phrase overdrawn. none number enough numerous manuscript

news flexible into several parts *Madeleine Vionnet, inventor of the bias cut in*

the early 1920s subsequently designed Möbius-band scarves in the 1930s. experience

experiences experienced wish wished wishful covering the

time in between *Use produces beauty as a by-product.* many other many days

many times many of the many of them few days few days ago

in a few days few months few moments few thousand dollars

sunset years conflicting as time permits, become due anywhere anyhow

whoever whatever everyone everywhere *Abstract art: a construction*

site for high fashion, for advertising, for furniture. up to the minute crumple-up

approval factory to withstand only one of its kind an opening entire

built rebuilt felt melt dealt fault an automatic device for

regulating temperature including much empty cold not capable of

occurring not appropriate not fully developed not essential not

polite rude for the final time noted parted needed reported

started proceeded no two chairs seem to be alike send sends sender

out outside outcome the cancellation mark of the post office don't

waste the pauses in the not-too-distant New York at noon to an appointment in

Paris later the next leaves for as yet has not yet has not been

have not yet I have not yet we have not yet seven-hours hyphenated

before *Space is no more stable than the next tremor . . . je tai dans la peau**

crossing the Atlantic inclined to favour one thing more than another

(if you are not attentive) in the form of pictures interview future

unit unite united few futile fuse But, that's what you said *I

have you in my skin (under) that is we can in this to

have so that

(Seen)

synaesthetic palindrome (possibilities of?)

first appears on a watermarked page

glass tipped to close the space

apart now contraction known as

a sign of displeasure

mimics gesture too far from

or for its book

Elle a des idées noire . . . the world was no longer a marvellous alphabet for her***

translate this page for me

word for word he's in the garden in the month of

 you're talking nonsense where is the accent in this

 word? we met by chance

 an accomplished fact

 his story doesn't agree with yours

I'm used to it by now

 let him finish a comedy in three acts

 something unexpected occurred it's a matter of

taste rush hour hiding-place

 what's the matter? nowhere else

 so to speak out of

doors I know the tune alibi to arrange in a line a one-way ticket

off the air

 to make one's appearance what's her name?

 applause it's not hard to learn a foreign language

if you don't have what I want, give me something like it

 here's an example which supports my argument

the performance begins at three p.m. what's the next stop?

take two steps backwards the importation of this article is prohibited

ace of spades I don't attach any importance to it

wait a minute we're expecting company

 in the meantime pay attention to what's going on

it doesn't matter at all formerly it was completely different

to use one's influence with someone as little as

possible, no sooner said than done a bus stop give me something

else

otherwise that won't get you very far

consider it will take you a long time, you'll have a long wait

to lower one's eyes

. . . rush headlong into a trap

swing, sway

to keep aloof

I'll see you over there

many of us

I'll intervene if need be

capital goods

how much are the tickets?

leave a few blank lines

to look someone straight in the eye

you have a free hand

noun and adjective wounded

a number of

crowded, packed

the rim of a glass

border design

mouthful

to overthrow

dial tone extremity

from one end to the other

to have at one's fingertips

frequently

they walked arm-in-arm

there's a rumour in the city that they're going to leave

suddenly

raw material

gather up the papers that are scattered on your desk

❖

here and there

caressing compose

yourself

we live in the country now

as endearment address book merry-go-round

last night I had my fortune told road map occasion

one may indeed say so

on no account in that case

waterfall registry

a flat refusal

do you know the facts of the case?

this, that, these, those

ignorance of the law is no excuse

in the centre

nevertheless I should like to have gone there

vicious circle

that is to say

each one of us thought the same room facing the front we went there at once

repeatedly to see stars

what sort of a story are you telling me?

everything in its time

to capsize, turn upside down the right way

put it in your pocket — it's your turn to play

 arrival platform

 to dislocate

 overflowing

overflow, flood

to unbutton

debut

I can't read this letter

shutter release

change of scenery

a rambling conversation

outside and inside

to unpack the bags

keep off the grass

what's the definition of this word?

degree, extent

beyond

without delay

three moves are as bad as a fire

can you tell the difference?

to untangle a plot

unexpected departure

this word is derived from Latin

ever since

unwelcome news

out of balance

as a last resort

what else would you like?

we found everything in disorder

from now on designedly

the book's on the top of the book shelf

a detailed account

out of order

as two drops of water

every other week

motto

we must do it

application

dimension to diminish

the art of speaking well

that's said but it's never written

(*should be whispered . . .*)

to change direction

tell right from wrong

to disappear

means of action

interval: keep at a distance

several times change, reveal

what is your home address?

a gift for languages

accordingly, just think!

take a look at double-lock a door

go easy

the entrance fee is expensive

short-lived

to last

❖

etching dumbfounded the explosion shook

the house he keeps in the background

to move aside in exchange for overlook falling due

in that case let's play a game of chess to echo

it fell to me to tell him bark, rind, peel out of print

effervescence that attracts attention the ceiling collapsed

do you mind if I shut the door? considering the circumstances

flight of imagination tall and slim each of them themselves

the furthermost near future

 embargo an embarrassing position

used only in the following phrase: at once right away broadcasting

emigration make it into a parcel

 what kept you from coming? directions for use

take all that away impression fingerprints

into, in, to, within

 some, any; of him, of her, of it, of them; from there

do they have any books? — they have many of them

they know at once what the other is going to say it goes without saying

word with a double meaning

enthusiasm intermission

go into this room

 it never entered my mind that . . . mezzanine

it must be about five o'clock

a safety pin episode

that book is out of print

 we wandered around the whole night

nonstop flight staircase

 to elude out of breath

two and two so be it

the study of languages themselves pattern; sample

to experience it was done on purpose

the trademark

look on the opposite side an awkward incident

one way or another by no means two and two are four

to pay attention, meet the needs of deliver a message handmade

 it's getting late

these things seldom occur

 we must admit that it's partly our fault

I've seen that face before *what's your last name?*

caprice

slip in or out of a place . . . bend a key

for want of something better wrong number

this fashion is in vogue to seal a letter . . . zipper

the traffic light changes to red

leaf through a book form, shape, face to imagine

this trick is too obvious he knows all about the intrigue

to stop

there's no end to it payable at the end of each month

torch to flame to blaze fluctuation

well, never mind once does not make a habit

under compulsion break open formality in all aspects

you're the limit!

noun and adjective point of bifurcation quiver

keep company with border

. . . in the following . . . *as soon as*

❖

here is roughly what I understood

quotation marks

skillfulness dressed where are you living now?

one gradually gets used to it

she read that book in one sitting (I wrote it in a hurry)

see if you can find it up there on time horizon

no longer used it's altogether out of the question

 they stopped at the hotel

❖

 in the meanwhile until then before long

to imagine things do as you see fit she has the blues*

identify identification papers

language, dialect there are others boundless illegible

imminent an odd number

blind alley to exhaust someone's patience

no matter when do it some way or other

anywhere any . . . at all imposed conditions

unforeseen difficulties printed matter to improvise

inaccessible unusual to set a fire doubt

blue is her favourite colour enclosed herewith incognito

stranger unknown this place is unfamiliar to me

there's no objection to that independence sign, mark

if you don't mind my asking, what happened?

he lives by his wits unpublished

information uninhabitable lack of intelligence

uninterrupted the fools have all the luck . . . I'm going to say inseparable

suggestion to inhale *just a minute*

follow the directions instrument without the knowledge of

to take an interest in someone by means of *question mark*

long-distance uncompromising

intuition inventory in the opposite direction

tincture of . . . to burst into a room

❖

incorrect language

a fountain

to be at stake

join in

what's today?

(an official request)

till, until, as far as

it's just what I want

to place side by side

❖

distance

❖

here and there

to loosen, relax, release

thereupon

allow oneself

width

do it right away

reading

the next

day that belongs to them

. . . on the tip of my tongue lipstick

generosity to be on the spot

follow the railroad track

drop me a few lines

have you ever read this book?

to stay in bed

literal meaning

literature

to give way to

premises

expression

do you see them over there in the distance?

at long intervals

alongside of to walk to and fro

lengthwise many years

rooms to let

there isn't enough light

(capricious Monday moon)

❖

what-do-you-call-it?

instinctively

engine

typewriter

sewing machine

steam engine

the machinery

to plot someone's ruin

the charm of her smile

a majority of five votes — that's not very much

they've acted secretly

he was told to take it or leave it

there is an abundant labour supply in this region

it's your turn now

right now

do you think it's going to last long?

not only . . . but also . . .

it's a case of absolute necessity

to tell right from wrong

perhaps it's a blessing in disguise

male or female

there's some misunderstanding there

manoeuver to know how to handle words

a would-be painter

a few steps farther down margin, border

disguised

to broach a subject the table of contents on Saturday mornings

unrecognizable distrust better, best; preferable

mixture shuffle the cards

attend to your own business (it amounts to the same . . .)

today, this very day we'll go even if it rains

still, you could have told me!

to be in a position to memory

that won't lead to anything

transport service take the measurement of

gradually to beat time

. . . put the finishing touches on something

I can't find my hat piece of furniture halfway

underhand intrigue microbe would you rather stay or go?

one couldn't ask for anything better

to cut in half lowercase

mirage realization putting into effect

under one's breath mobilization

manners change with the times

give it to me myself

It's an hour less a quarter unless

do you want half of this apple?

don't do things halfway

now is the time since it doesn't interest you not for the moment

everywhere in the world

monetary counterfeiter monologue

rising to point out something to someone

dead silence

to tell you everything in two words crossword puzzle

without any reason on what do you base your decision?

let's get back to the subject

to be in motion animated means

to multiply ammunition

legend

❖

this rumour sprang up recently

to breed contempt I wasn't born yesterday

pledge a sly smile

what nationality are you? still-life painting

to pay in kind

that's certainly not very reassuring

to see things as they are natural death life-size

of course I'll do it

he was ship-wrecked in sight of the harbour

we must tread lightly here

scarcely never isn't that so?

not at all nothing to report nebulous

we're taking all necessary measures

to be compelled to do something

this will oblige us to leave through an oversight

snow to snow neon

it's very clear neither this one, nor that one

foolishness to see the dark side of everything pseudonym

. . . win a name for oneself number

a good many people are of the same opinion

appointment nonchalance she isn't her usual self

there is a notice in the paper about that

the explanation is given in the footnotes

these are things to watch for later on

biographical sketch idea notoriety

again, once more who gave you that information?

at nightfall to number

❖

it's dark here

hint be careful, you're being watched

we rarely have occasion to go there

all the seats are taken

one never knows where are we going?

to be stubborn it's quite the contrary

choice now then . . . well then . . .

in the orchestra you can sleep soundly

he lost his sense of direction

spelling to oscillate

. . . forget myself

beyond all measure

work, performance

. . . opened negotiations . . . sharpen the . . .

oxygen

❖

an even number they are two of a kind

palpitation panic

breakdown panorama

butterfly by means of parachute

when will the book appear?

to cover the difference

relationship parentheses

to keep one's word share, division

starting from tomorrow

your letter finally reached me

it's only a few steps away the streets of Dover

not for the moment passerby

on the debit side no free admission

helter skelter while you're at it peninsula

to jeopardize out of date

adventure permanent permission

a search warrant

I'm not at home to anybody

as far as the eye can reach

relevant disturbance weigh your words carefully

phenomenon heads or tails to show someone the way

a turning point in history

everything is done on the premises

foreground high tide point of view

little or none at all policy

close the door to begin with forever

it's in the chapter before this one

just now to lend itself evidence

approaching it had no effect

how do you pronounce it?

a temporary job

what then?

❖

than, that, as, what

who, whom, which, that

❖

reasoning to slow down bitterness

keep the crowd back

in this respect we don't agree

to make a clean sweep

razor blade feel

reassured crossing out havoc studied elegance

they didn't recognize one another

to reconsider you were tricked

look at that

there's no performance tonight

substitute don't move around so much

to make good the damage

. . . without a word

answer

many times

that doesn't solve the problem

general delivery to remain

a round-trip ticket become narrow

alarm clock disclosure that comes to less

nothing else

road map

streaming

❖

a lifeboat

to examine closely

emergency exit

it's an open secret

upside down

the effects are still being felt

signing

as simple as ABC

would be

myself

in care of

does this happen often?

he's able to go there whereas we have to stay here

so many people such a crowd

remote control please hold this book

to feel one's way a private conversation

the construction of a sentence that refers to what has already been said

plot to weave anxiety transfer

a transit visa

breadth, width across country you've misunderstood everything

to disguise thirteen

an earthquake most of the time three times a day

these are empty promises this is what fools you

that tune keeps running through my head

a tool kit did you find it?

typical

goods for future delivery

this part of the construct was added subsequently

they arrived one by one

you can't tell which is which

organize your ideas

a solid colour

one-way street

these facts are closely connected

to suit the action to the word

use an antiseptic

polite expressions

this material wears well

I'll do it in due time . . . useless

❖

coming and going

indefinite colour

empty promises

this passport is valid for a year

better late than never

the weather is changing

spacious vaudeville

business is slow

a hungry stomach has no ears

a regular verb

truth will out

the answer is written on the back

. . . wrong use of a word

to stare into space

exposed

lookout

. . . there's a curve in the road

comma

entrance visa

. . . always trying to create an impression

guided tour

to change gears

vocabulary

here's the book

what do you see?

that happens every day

two adjoining rooms

flight

take your choice

you want it, don't you?

a story that sounds true

since, whereas, seeing that

❖

.

❖

.

❖

.

** phrase from *What Never Dies*, Barbey D'Aurevilly

❀

T
H
E
R
E
I
S
N
O
W
H
Y
I
N
E
G
Y

THERE IS NO **Y** IN EGYPT*

* LINE IN 1943 FILM *FIVE GRAVES TO CAIRO* DIRECTED BY BILLY WILDER

61

CODA

a sequence queuing proposed

spiral latitude, along

dialogue, attitude meandering as or is

longitude apart from/of framing

semblances or some roses risen

undone in too

inclining is as does the red

opting of chance *change*

meaning is

when reading's absent

from the written sense

left or raking torn

the idea of words is present

spoken or not quipu holds a tongue

twisted intervening as happens since

learning leaves

an *r* wrap utterance

Sources

Butter, Henry. *Butter's Spelling*. London: Simpkin and Co., Longman and Co. et al, 1860.

Flower, Margaret. *Jewellery 1837–1901* [1951]. New York: Walker and Company, 1968.

Hawkins, Laurence F. *Notescript: A Self Taught System of Rapid Writing*. Barnes & Noble, 1964.

Lazar, Liliane. *Living Language™ Conversational French Revised & Updated* (based on the original by Ralph Weiman). New York: Crown Publishers, Inc., 1993.

Lazar, Liliane. *Living Language™ French Dictionary Revised & Updated* (based on the original by Ralph Weiman). New York: Crown Publishers, Inc., 1993.

ABOUT KAREN MAC CORMACK

Karen MacCormack is the author of more than a dozen books including, most recently, *Tale Light* (Book Thug/West House Books 2010). Her previous books from Chax Press are *Quirks & Quillets*, *The Tongue Moves Talk*, *Implexures* (volume 1, with West House Books), and *Implexures* (complete edition).

ABOUT CHAX

Founded in 1984 in Tucson, Arizona, Chax has published 200 books in a variety of formats, including hand printed letterpress books and chapbooks, hybrid chapbooks, book arts editions, and trade paperback editions such as the book you are holding. In August 2014 Chax moved to Victoria, Texas, and is presently located in the University of Houston- Victoria Center for the Arts, which has generously supported the publication of *Rechelesse Pratticque*, which has also received support from many friends of the press. Chax is an independent 501(c)(3) organization which depends on support from various government private funders, and, primarily, from individual donors and readers. In Summer 2018 Chax is moving to Tucson, Arizona, but will also continue its presence in Victoria, Texas..

Recent books include *The Complete Light Poems*, by Jackson Mac Low, *Life-list*, by Jessica Smith, *Andalusia*, by Susan Thackrey, *Diesel Hand*, by Nico Vassilakis, *Dark Ladies*, by Steve McCaffery, *What We Do*, by Michael Gotlieb, *Limerence & Lux*, by Saba Razvi, *Short Course*, by Ted Greenwald and Charles Bernstein, *An Intermittent Music*, by Ted Pearson, *Arrive on Wave*, by Gil Ott, *Entangled Bank*, by James Sherry, *Autocinema*, by Gaspar Orozco, *The Letters of Carla, the letter b.*, by Benjamin Hollander, *A Mere Rica*, by Linh Dinh, *Visible Instruments*, by Michael Kelleher, *What's the Title?*, by Serge Gavronsky, *At Night on The Sun*, by Will Alexander, *The Hindrances of Householders*, by Jennifer Bartlett, *Mantis*, by David Dowker, and *Who Do With Words*, by Tracie Morris.

You may find CHAX at *https://chax.org/*